Enjoy
Entrelac
Knitting

Enjoy
Entrelac
Knitting

Brenda Horne

Kangaroo Press

Acknowledgments

I would like to thank the following for their help and support in the creation of this book: Sunny Bidner, Kerry Garland, Shirley Jarzabek, Jenny Livingston, Pam North, Marian Sinclair, all the models and Dan Sobolewski for the photography.

First published in 1993 by Kangaroo Press Pty Ltd
3 Whitehall Road Kenthurst NSW 2156 Australia
P.O. Box 6125 Dural Delivery Centre NSW 2158 Australia
Typeset by G.T. Setters Pty Limited
Printed in Hong Kong through Colorcraft Ltd

ISBN 0 86417 554 X

Contents

Introduction

In this book of knitting patterns I would like to share with you my passion for entrelacs. I have found this technique to have endless design possibilities. All that is needed is patience, imagination and a hoard of yarn.

The chart for each garment is supplied so that you can mark in your own design and colour scheme before commencing.

Entrelac designs are a marvellous way of using up all the odds and ends that every knitter has lying around; even quite short lengths can be utilised.

The standard practice of building the squares by working the base number of stitches, turning, and working them again is extremely tedious, so I recommend that you practice two-directional knitting before you tackle any of the garments, especially the hats.

I have included the pattern for a cushion cover for you to try if you have never worked entrelacs before and are a little hesitant, but first, here is a sample square to help you to understand the basic technique.

Sample square

This is worked in stocking stitch. Check the list of abbreviations on page 8 first.

| Step 1
Cast on 16 sts. | Base triangle | *K1, turn. P1, turn.
K2, turn. P2, turn.
K3, turn. P3, turn.
K4, turn. P4, turn.
Continue in this way until the row K8 has been worked. DO NOT TURN.
Rpt from * to end of row. ~~TURN~~.
DO NOT PANIC. Trust me. |

Step II	First triangle with WSF	P1, turn. Inc in this st, turn. P1, p2 tog, turn. Inc in first st, k1, turn. P2, p2 tog, turn. K1, inc in next st, k1, turn. P3, p2 tog, turn. K2, inc in next st, k1, turn. Continue to inc in this way until the row P7, p2 tog. DO NOT TURN.
Step III	Purl square with WSF	Pick up and purl 8 sts along row ends of previous row, turn. (K8, turn. P7, p2 tog, turn) 8 times. DO NOT TURN.
Step IV	Second triangle with WSF	Pick up and purl 8 sts along row ends of previous row, turn. K8, turn. P6, p2 tog, turn. K7, turn. P5, p2 tog, turn. K6, turn. Continue in this way until one st remains. Fasten off, but do not break yarn unless changing colour. TURN.
Step V	Knit square with RSF	*With RSF pick up and knit 8 sts along row ends of previous row, turn. (P8, turn. K7, SSK, turn) 8 times. DO NOT TURN. Rpt from * to end of row. TURN. Rpt Steps II, III and IV.
Step VI	Knit cast-off triangle with RSF	*Pick up and knit 8 sts along the side of the triangle/square just worked, turn. P8, turn. K7, SSK, turn. P6, p2 tog, turn. K6, SSK, turn. P5, p2 tog, turn. K5, SSK, turn. Continue decreasing until one st remains. Fasten off, but do not break yarn unless changing colour. Rpt from * to end of row.

There—that wasn't too bad, was it?

Abbreviations

alt	alternate
dec	decrease
dc	double crochet
inc	increase
K or k	knit
k'wise	knitwise
LH	left hand
M1	make one
P or p	purl
p'wise	purlwise
PU	pick up
Rpt	repeat
RSF	right side facing
RH	right hand
SSK	slip 1, slip 1, knit these 2 sts tog
SKP	slip 1, knit 1, pass the slipped st over

st/s	stitch/stitches
st st	stocking stitch
tog	together
tw	twist
WSF	wrong side facing
YO	yarn over
yfwd	yarn forward
turn	turn and work across this group of stitches only (This may be eliminated if using two-directional knitting.)
TURN	turn and work across each group of stitches to the end of the row
row	this may refer to either a short row across only the group of stitches being worked OR a row of squares across the width of the garment

Technical notes

Some other bits and pieces you will need for working the garments.

Purl cast-off triangle with WSF

Pick up and purl the required number of stitches along the side of the triangle/square just worked, turn.
Knit to end, turn.
Purl to last st, p2 tog, turn.
Knit to last 2 sts, k2 tog, turn.
Purl to last st, p2 tog, turn.
Continue decreasing until 1 st remains.
Fasten off.

Triangle at beginning of knit row with RSF

K1, turn. Inc in this st p'wise, turn.
K1, SSK, turn.
Inc in first st, p1, turn.
K2, SSK, turn.
P1, inc in next st, p1, turn.
K3, SSK, turn.
P2, inc in next st, p1, turn.
Continue increasing in this way until the desired number of stitches is reached.

Triangle at end of a knit row with RSF

PU the required number of stitches, turn. (P to end, turn. K to last 2 sts, k2 tog, turn) until one stitch remains. Fasten off.

Half triangle at end of row

PU required number of sts, turn.
Work to last 2 sts, work 2 tog, turn. Rpt last row until 1 st remains.
Fasten off.

Half triangle at beginning of row

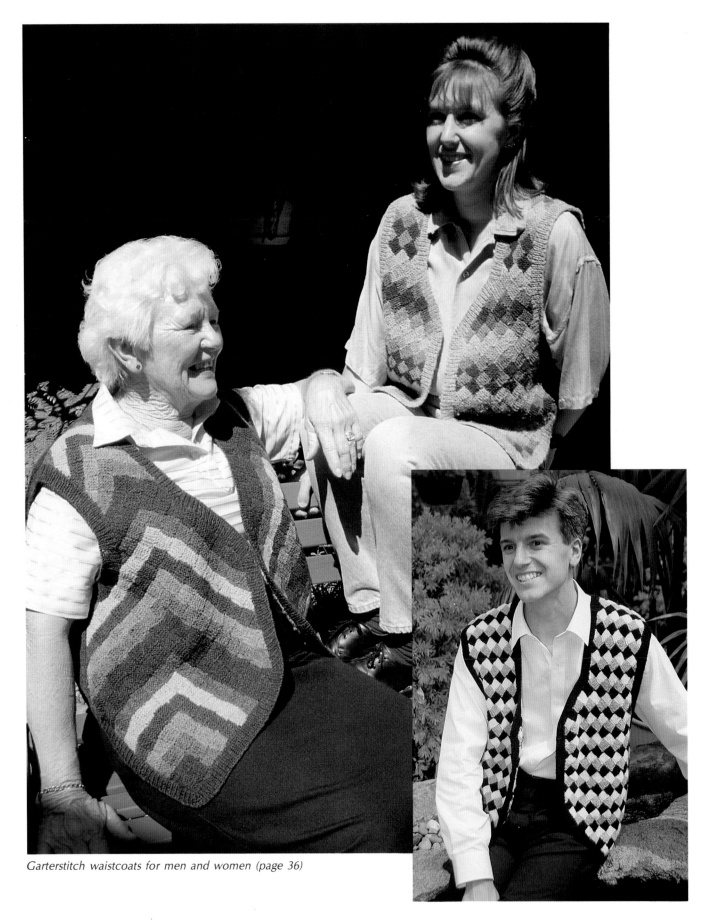

Garterstitch waistcoats for men and women (page 36)

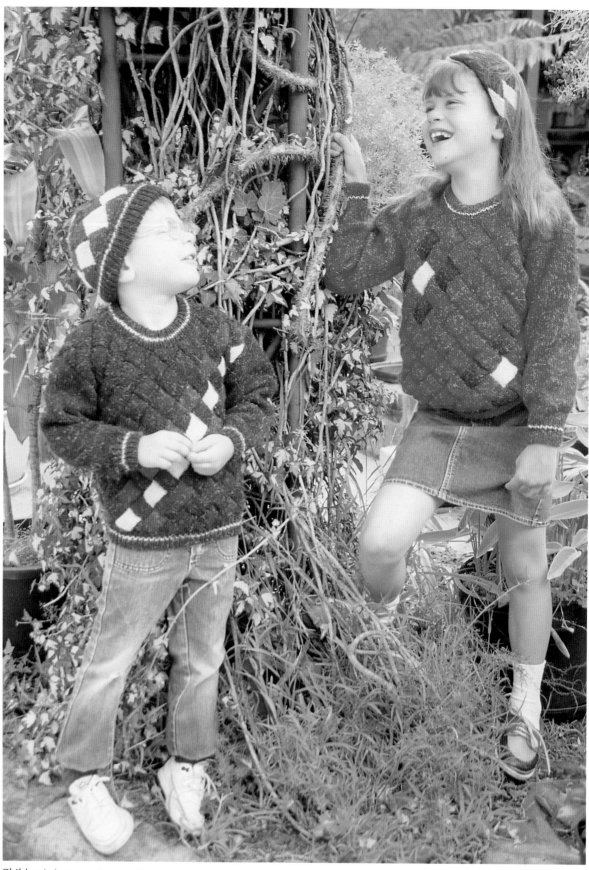

Children's jumpers (page 20)

10

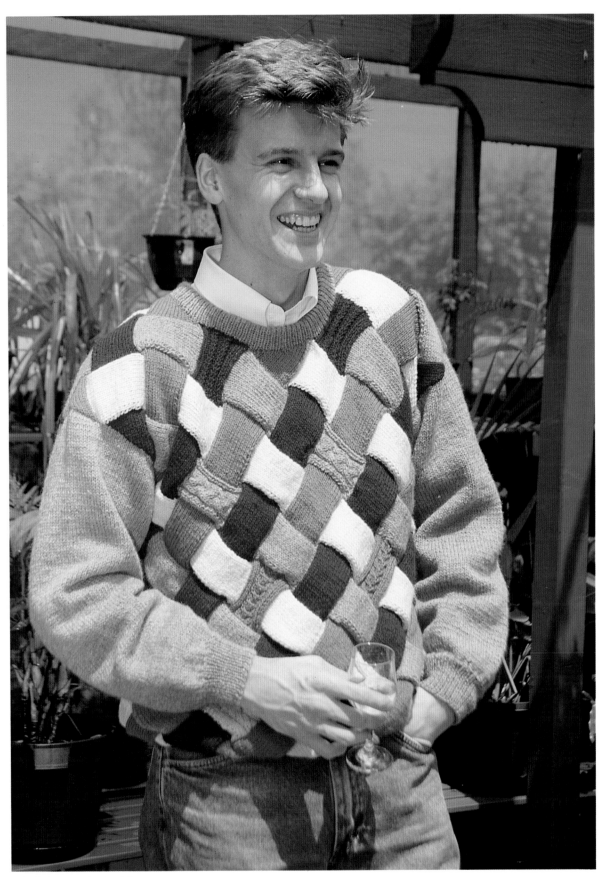

Man's jumper (page 22)

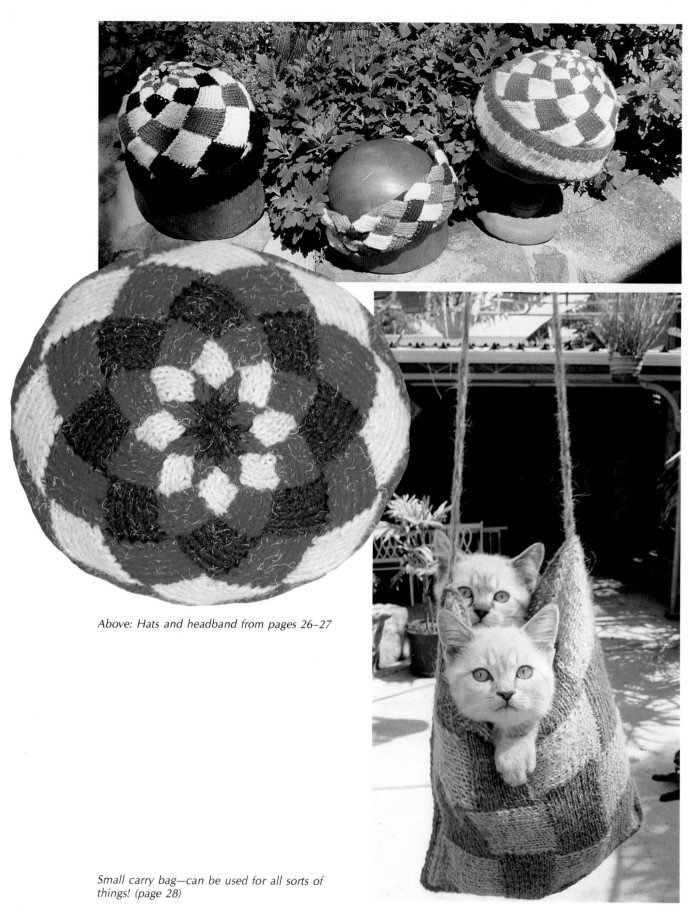

Above: Hats and headband from pages 26–27

Small carry bag—can be used for all sorts of things! (page 28)

Work as for first triangle with WSF until there are the same number of stitches on each needle, turn.
Work 1 row without shaping, turn.
Work to last st, work 2 tog, turn.
Work to last 2 sts, work 2 tog, turn.
Rpt last 2 rows until 1 st remains.
Fasten off.

Two-directional knitting

You may suppose that because this technique is strange to you that it will be much slower, but when working short rows, as in entrelacs, think of all the time you will save by not having to constantly turn the work. Not to mention the wear and tear on arms and shoulders. You will find it easier if you can hold the right-hand needle on top, as you would a dinner knife.

With RSF, knit each stitch in the English way. Without turning work, purl back along the row by inserting the LH needle into the back of the first stitch from front to back, wind yarn around the needle anti-clockwise. See Figure 1.

Hook yarn through the stitch and lift it off the needle. Work to the end of the row in this way. Repeat the last two rows until you are familiar with them. TURN.

With WSF, purl each stitch in the English way. Without turning work, knit back along the row by inserting the LH needle into the back of the first stitch, from back to front, and wind the yarn around the needle anti-clockwise. See Figure 2.

Hook yarn through the stitch and lift it off the needle. Repeat the last two rows until you are familiar with them.

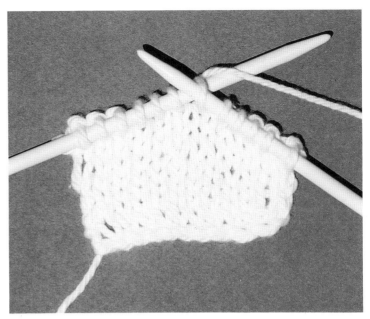

Figure 1

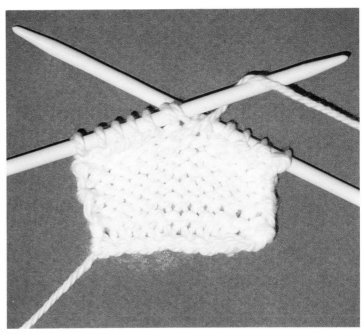

Figure 2

Rib cable cast on

This method of casting-on is to be used with single rib.

Make a slipknot and place it on LH needle. Insert RH needle and draw a loop of yarn through.

Place this loop on LH needle.
*With yarn in front, insert RH needle between the two stitches from behind (as if to purl) and draw through a loop.
Place this loop on LH needle.

With yarn at back, insert needle between the last two stitches from the front and draw through a loop.
Place this on LH needle.

Repeat from * until you have the required number of stitches (an odd number).
1st row: K2 (p1, k1) to last st, k1.

You will notice that the knit stitches jump forward and the purl stitches fall back.

Provisional cast on

This method of casting-on is to be used when you are going to return to this spot and work in the opposite direction.

Using a contrast yarn and a fairly large crochet hook, work a chain of crochet a few stitches longer than the number of stitches you need.

Pick up the required number of stitches for the pattern by working into the loops on the back of the crochet chain. See Figure 3.

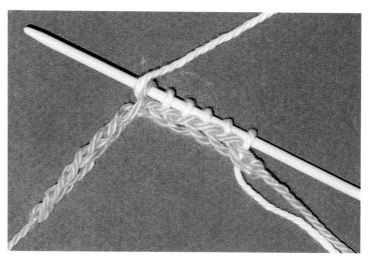

Figure 3

This pick-up row counts as the first knit row, and enables you to work your garment and return to the basque when you are satisfied with your project. (There's nothing worse than having to work the basque in order to start on a creation only to find later that you have to undo it because the design is not what you wanted.)

Invisible cast on

This method is to be used with single rib where a very neat, firm edge is required.

Work a crochet chain as above, but make only half the number of stitches that you need. On the pick-up row, use needles two sizes smaller than those recommended for the basque, and bring the yarn forward to make a YO between each stitch.

Finish with a knit stitch, therefore an odd number.

1st row: With yarn in front, slip the first stitch as if to purl.

*Take the yarn to the back and knit the YO of the row below. Yarn forward, slip the next stitch purlwise.
Rpt from * to end of row.
2nd row: Knit the first stitch. *Slip the next stitch purlwise as before. Knit the next stitch. Rpt from * to end of row.
3rd row: As 1st row.
4th row: As 2nd row.

This counts as two rows. Change to the size needles recommended for the basques and continue to work in rib for the required distance.

When the basque is complete the crochet chain is easily removed.

Invisible cast off

This method is to be used with single rib.

When the last row or round of ribbing is complete, cut the yarn three times the width of the work. Thread a large blunt needle with the yarn.

If your row starts with K1, p1, then start with Step I. If your row starts with K2, p1, then start with Step II.

Step I: (First stitch on LH needle is knit.)
Insert needle into the first stitch as if to knit and drop the stitch off.

Insert the needle purlwise in the second stitch now on the LH needle and pull the yarn through.

Step II: (First stitch on LH needle is purl.)
Insert needle into first stitch purlwise and drop stitch off.

Bring needle through from back to front between first and second stitches now on LH needle (see Figure 4), take needle back through the second stitch knitwise and pull yarn through.

Repeat both Steps I and II until the end of the row or round. Fasten off.

Mattress stitch

This stitch is used to join two selvedges together.

Place pieces to be joined side by side with right side of the work uppermost. Thread a large blunt needle with yarn, and bring it up through

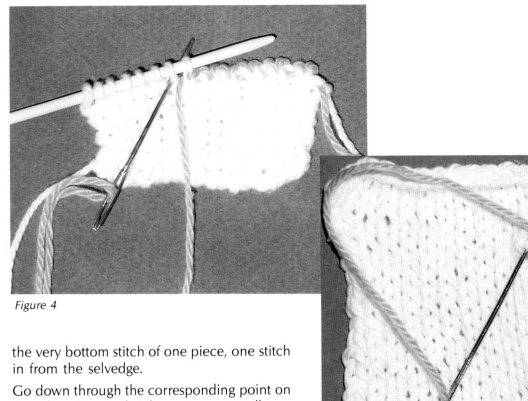

Figure 4

the very bottom stitch of one piece, one stitch in from the selvedge.

Go down through the corresponding point on the other piece and pick up two rows, pull yarn through, leaving a tail for darning in, but do not pull tight.

Take needle back down where it came up on the first piece and pick up two rows, pull yarn through.

Continue to work from side to side (see Figure 5). After working about 3 cm pull yarn firmly, to close seam, before continuing.

Figure 5

Grafting stitches to row ends

This technique is used for joining entrelac pieces together.

Using the yarn left on the work, thread a large blunt needle.

*Bring yarn up through the first st. Pick up two rows from row ends of facing square (see Mattress stitch). Pull yarn through.

Insert needle back down through the first stitch on the needle and drop the stitch off. Repeat from * to end of row. See Figure 6.

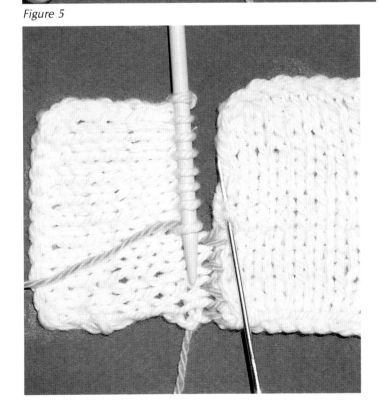

Figure 6

Figure 7

Short rows

This method is to be used instead of casting off at shoulders or at the top of the sleeves for a dropped shoulder.

Knit across to the required number of stitches, yarn forward, slip the next stitch purlwise, take the yarn to the back of the work and return the slipped stitch to the left-hand needle, making sure not to twist it.

Turn the work and purl across to the required number of stitches, slip the next stitch purlwise, take the yarn to the back (away from you) and return the slipped stitch to the left-hand needle, taking care not to twist it.

Turn the work and repeat for the required number of times.

When shaping is complete knit or purl across the row, picking up the wrapped yarn from the right side of the work, and knit or purl it together with the stitch around which it was wrapped. See Figure 7. Turn, and work another row, picking up the wrapped stitches on the second half of the row if necessary (as on the tops of sleeves or back of garments.)

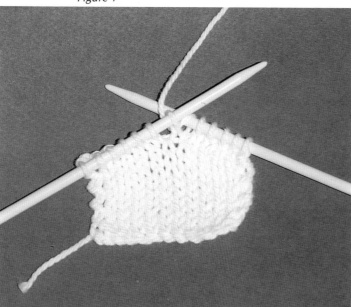

Figure 8

Increasing

Raised increase: Mainly used after ribbing as it can be worked between knit or purl stitches on the right or wrong side of the work.

Pick up the yarn of the row below, between two stitches, and place on the LH needle. Knit or purl into the back of this loop so as to twist it, thus preventing a hole.

Lifted increase: Used where the increasings are not to be visible, e.g. sleeve seams.

Working at least one stitch in from the edge of the work, pick up the bar of the row below on the next stitch. See Figure 8.

Knit it before working the stitch in the normal way.

Increase in next stitch: Knit into the front and then the back of the stitch. See Figure 9.

This method is very noticeable and is not normally recommended, but when working selvedges on entrelacs I will allow you to use it.

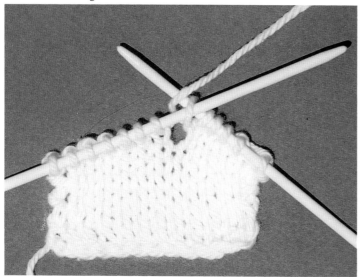

Figure 9

To start with . . .

Cushion cover or carry bag
(*inside front cover*)

Work in one colour, two colours, or with each square a different colour.

If you try out the patterns before working a garment you can build up a collection of cushions in all different designs.

Using 8-ply yarn and 4 mm needles, cast on 48 sts.

To form base triangles:
*K1, turn. P1, turn.
K2, turn. P2, turn.
K3, turn. P3, turn.

Continue in this way until the row K12 has been worked. DO NOT TURN.

Repeat from * 3 times more. TURN.

1st row: P1, turn. Inc in this st, turn.
P1, p2 tog, turn. Inc in first st, k1, turn.
P2, p2 tog, turn. K1, inc in next st, k1, turn.
P3, p2 tog, turn. K2, inc in next st, k1, turn.

Continue to increase in this way until you reach the row P11, p2 tog. DO NOT TURN.

*With WSF, PU p'wise 12 sts along row ends of previous row, turn. (K12, turn. P11, p2 tog, turn) 12 times. DO NOT TURN.

Rpt from * twice more.

PU p'wise 12 sts, turn. K12, turn.
P10, p2 tog, turn. K11, turn.
P9, p2 tog, turn. K10, turn.

Continue to dec until 1 st remains. Fasten off but do not break yarn unless changing colour. TURN.

2nd row: With RSF PU k'wise 12 sts along edge of triangle just worked. (P12, turn. K11, SSK, turn) 12 times. DO NOT TURN.

Work 3 more squares the same. TURN.

Repeat first and second rows twice more and the first row once again.

PU k'wise 12 sts along edge of triangle just worked, turn.
P12, turn. K11, SSK, turn.
P10, p2 tog, turn. K10, SSK, turn.
P9, p2 tog, turn. K9, SSK, turn.

Continue in this way until 1 st remains. Fasten off.

Work 3 more triangles the same.

Make a second piece the same as the first.

Sew a zip in between the cast-on edges and join the other 3 sides with a row of double crochet. Attach strap for a bag.

Family sweaters in 8-ply

These jumpers for the family incorporate a variety of design suggestions: a main colour with contrast pattern in the child's jumper, four shades worked in a woven design for the woman's. The man's jumper has a few patterned panels added for interest. Use the charts provided to plan your design before beginning. The sleeves have been left plain because it is not possible to shape them in the entrelac

pattern: they would be full and impractical. The cotton top on page 30 is from the woman's pattern but with stitches picked up for armbands rather than sleeves.

If you need a size that is not given here, it is a simple matter to make a larger size by adding one stitch per square. Use the directions at the beginning to work a test piece.

Infant's jumper in two colours
(inside front cover)

Finished chest measurement: 50 (56,62) cm
Materials: Worked in DK Baby Yarn:
 3 X 50 g balls of main colour (MC)
 2 X 50 g balls of contrast colour (C)
Tension: 24 sts to 10 cm over st st
Needles: 3.25 mm, 4 mm and set of 3.25 mm
 double-ended

Front
Using MC and 3.25 mm needles, cast on 63(69,75) sts in rib.
Work 9(11,13) rows of k1, p1 rib.
Change to 4 mm needles and st st.
Dec evenly across next row in purl to 42(49,56) sts.

Using MC, work 7 base triangles over 6(7,8) sts. See instructions on page 6.
Using C and MC alternately continue to work straight for a further seven rows.

Sleeves
With RSF, join in MC and cast on 24(28,32) sts.
Work 4 base triangles over 6(7,8) sts for left sleeve.
Work across body.
Using a spare length of yarn, cast on 24(28,32) sts on LH needle.
Work 4 base triangles over the stitches just cast on for right sleeve. TURN.**
With WSF continue to work across all stitches for 2 more rows. TURN.
Work 1 triangle, 6 squares, 2 purl cast-off triangles (see page 8), 6 squares and 1 triangle. TURN.

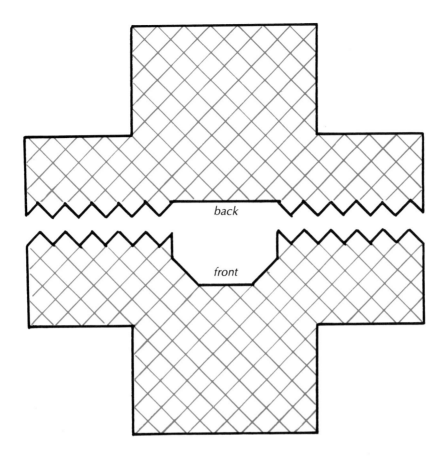

Left front

Work 6 squares, leave the last 6(7,8) sts on a safety-pin. TURN.
Work 5 squares and 1 triangle. TURN.
Work 5 squares and 1 triangle. Leave all these stitches on a holder.

Right front

With RSF return to sts at right front, slip the first 6(7,8) sts on to a safety-pin. Work 6 squares. TURN.
Work 1 triangle and 5 squares. TURN.
Work 1 triangle and 5 squares. Leave all these stitches on a holder.

Back

Work as for front up to **
With WSF continue to work across all stitches for 4 more rows. TURN.
Work 1 triangle, 5 squares, 4 purl cast-off triangles, 5 squares and 1 triangle.
Graft the front to the back. See page 15.

Neckband

Using MC and 3.25 mm needles PU and knit 6(7,8) sts across each square and triangle all around neck, commencing at back left shoulder.
Working back and forth work 9 rows in k1, p1 rib.
Cast off invisibly.
Make a button loop on front edge of neckband and sew a button on the back edge. Sew side and sleeve seams.

Cuffs

Using MC and 3.25 mm needles PU and knit 37(41,45) sts around sleeve ends and work 12(14,16) rounds in k1, p1 rib.
Cast off invisibly.

Child's jumper

(pagr 10)

Finished chest measurement: 66(74,82) cm
Materials: 7(8,9) × 50 g balls of 8-ply
Tension: 22 sts to 10 cm over st st
Needles: 4 mm, 3.25 mm and set of 4 ×
 3.25 mm (or a 40 cm circular needle)

Front

Using 3.25 mm needles cast on 69(75,81) sts in rib.
Work 11(13,15) rows in k1, p1 rib.
Change to 4 mm needles and with WSF decrease evenly across a purl row to 49(56,63) sts.
With RSF work 7 base triangles over 7(8,9) sts.**
Continue to work straight for a further 11 rows. TURN.
With RSF work 3 squares, leave the last 7(8,9) sts on a safety-pin, work 1 knit cast-off triangle and 3 squares. TURN.
Work 1 triangle, 2 squares, leave the last 7(8,9) sts on a safety pin. TURN.
Break off yarn. Rejoin yarn and work 2 squares. TURN.
Work 1 triangle, 1 square and 1 triangle. Leave these stitches on a holder.
Return to stitches at left front.
With WSF work 2 squares and 1 triangle. TURN.
Work 2 squares. TURN.
Work 1 triangle, 1 square and 1 triangle.
Leave all these stitches aside.

Back

Work as for front to **.
Continue to work straight for a further 15 rows. TURN.
With RSF work 2 squares, 3 knit cast-off triangles and 2 squares.
Graft back to front at shoulders.

Sleeves

Using 3.25 mm needles cast on 39(41,45) sts in rib.
Work 11(13,15) rows in k1, p1 rib.
Increase evenly across next row to 55(59,63) sts.
Change to 4 mm needles, and stocking stitch.
Inc at each end of the 5th and following 6th rows until there are 67(73,79) sts.
Continue straight until sleeve measures 28(33,38) cm or length desired.
Commence short row shaping (see page 16).

(Knit to last 6 sts, turn. Purl to last 6 sts, turn) 4 times, leaving 6 extra sts unworked each time.
Knit to end of row, picking up yarn wraps on the right side of work.
Purl across all sts, picking up yarn wraps on the right side of work on the second half of the row.

Join sleeves to body.
Sew side and sleeve seams, using mattress stitch.

Neckband

Using 3.25 mm needles and starting at back left shoulder, pick up and knit 84(92,100) sts around neck, increasing across sts on holders as needed.
Work 18 rounds of k1, p1 rib.
Cast off loosely, fold neckband in half and slip stitch to the inside.

Woman's jumper

(page 30)

Finished bust measurement: 95(105,115) cm
Materials: 750(800,850) g of 8-ply yarn
 (inc. at least 250(300,350) g in MC for sleeves
 and bands)
Tension: 22 sts to 10 cm over st st
Needles: 4 mm, 3.25 mm and a set of 4 ×
 3.25 mm

Front
Using 3.25 mm needles cast on 97(103,109) sts
in rib.
Work 17 rows in k1, p1 rib.
Change to 4 mm needles and with WSF dec
evenly across a purl row to 70(80,90) sts.
With RSF work 10 base triangles over 7(8,9) sts
(see page 6).**
Continue to work straight for a further 17 rows.
TURN.
With RSF work 4 squares, leave the last 7(8,9)
sts on a safety-pin, work 2 knit cast-off triangles
and 4 squares. TURN.
Work 1 triangle and 3 squares, leave the last
7(8,9) sts on a safety-pin. TURN.
Break off yarn. Rejoin yarn and work 3 squares.
TURN.
Work 1 triangle, 2 squares and 1 triangle.
Leave these stitches for now.
Return to stitches at left front.
With WSF work 3 squares and 1 triangle. TURN.
Work 3 squares. TURN.
Work 1 triangle, 2 squares and 1 triangle.
Leave all these stitches aside.

Back
Work as for front to **.
Continue to work straight for a further 19 rows.
TURN.
With RSF work 3 squares, 4 knit cast-off triangles
and 3 squares.
Graft back to front at shoulders.

Sleeves
Using 3.25 mm needles cast on 47(49,51) sts in
rib.
Work 17 rows in k1, p1 rib.
Inc evenly across next row to 73(79,85) sts.
Change to 4 mm needles and stocking stitch.
Inc at each end of the 5th and following 6th
rows until there are 91(97,103) sts.

Continue straight until sleeve measures 43 cm
or length desired.
Commence short row shaping (see page 16).
(Knit to last 7(8,8) sts, turn. Purl to last 7(8,8)
sts, turn) 5 times, leaving 7(8,8) extra stitches
unworked each time, turn.

Knit to end of row, picking up yarn wraps on
the right side of work.
Purl across all stitches, picking up yarn wraps
on the right side of work on the second half
of the row.

Join sleeves to body.
Sew side and sleeve seams with a mattress
stitch.

Neckband
Using 3.25 mm needles and starting at back of left shoulder pick up and knit 124(136,148) sts around neck, increasing across sts on holders as needed.

Work 20 rounds of k1, p1 rib.
Cast off loosely, fold neckband in half and slip stitch to the inside.

Man's jumper
(*page 11*)

Finished chest measurement: 95(105,115) cm
Materials: 900(950,1000) g 8-ply yarn
 (inc. at least 300(350,400) g in MC for sleeves and bands)
Tension: 22 sts to 10 cm over st st
Needles: 4 mm, 3.25 mm and a set of 4 × 3.25 mm (or a 40 cm circular needle)

Front
Using 3.25 mm needles cast on 103(109,115) sts in rib.
Work 21 rows in k1, p1 rib.
Change to 4 mm needles and with WSF dec evenly across a purl row to 72(78,84) sts.
With RSF work 6 base triangles over 12(13,14) sts (see page 6).**
Continue to work straight for a further 10 rows.

With WSF work 1 triangle and 2 squares, leave the last 12(13,14) sts on a holder.
Work 1 purl cast-off triangle, 2 squares and 1 triangle. TURN.
With RSF work 2 squares. TURN.
Work 1 triangle, 1 square and 1 triangle. Leave these stitches aside and return to sts at right front.
With RSF work 2 squares. TURN.
Work 1 triangle, 1 square and 1 triangle. Leave these stitches aside.

Back
Work as for front to **.
Continue to work straight for a further 11 rows. TURN.
With RSF work 2 squares, 2 knit cast-off triangles and 2 squares.
Graft front to back at shoulders.

Sleeves
Using 3.25 mm needles, cast on 51(55,59) sts in rib.
Work 19 rows in k1, p1 rib.
Inc evenly across next row to 79(85) sts.
Change to 4 mm needles and st st.
Inc at each end of the 5th and following 6th rows to 107(111,115) sts.
Work straight to 48 cm or length required.

Commence short row shaping (see page 14). (Knit to last 7(8,9) sts, turn. Purl to last 7(8,9) sts, turn) 5 times, leaving 7(8,9) extra stitches unworked each time, turn.

Knit to end of row, picking up yarn wraps on the right side of work.

Purl across all sts, picking up yarn wraps on the right side of work on the second half of the row. Cast off.

Join sleeves to body.
Sew side and sleeve seams.

Neckband

Using 3.25 mm needles and starting at back of left shoulder, pick up and knit 124(136,148) sts around neck, increasing across sts on holders as needed.

Work 20 rounds in k1, p1 rib.

Cast off loosely, fold neckband in half and slip stitch to the inside.

All-in-one woman's jacket
(page 29)

Sizes: 10–14 (16–18)

Materials: Approximately 900(1000) g of oddments and at least 200 g of main colour in 8-ply yarns.

Tension: 22 sts to 10 cm over st st

Needles: 4 mm and 3.25 mm long circulars; set of 4 X 3.25 mm

Front and back (worked in one piece to armholes)

Using 3.25 mm needles and MC cast on 199(239) sts in rib.

Work 19 rows in k1, p1 rib.

Change to 4 mm needles.

Next row: P4 (p2 tog, p3) 39(47) times to 160(192) sts.

Work 20(24) base triangles over 8 sts (see page 6).

Work 14(16) rows straight.

Divide for armholes.

Left sleeve

Using MC and a spare 4 mm needle, cast on 56(64) sts, using the provisional method (see page 14).

Make 7(8) base triangles and set these aside for the left sleeve. Break off yarn.

Commencing at centre left front and with WSF work a beginning triangle and 4(5) squares, work 7(8) squares and an end triangle across triangles left aside for sleeve. TURN.

Work straight for a further 5 rows. TURN.

With WSF work 1 half triangle (see page 8), 11(13) squares and 1 triangle. TURN.

With RSF work 11(13) squares (leave the last 8 sts worked on a safety pin). TURN.

Work 10(12) squares and 1 triangle. TURN.

Work 10(12) squares and 1 triangle. NB: leave a length of spare yarn on each square before breaking off, to be used for grafting.

Leave sts on a holder.

Right sleeve

Using MC and spare 4 mm needles, cast on 56(64) sts using provisional method.

Work 7(8) base triangles.

With WSF, work over the triangles just made and right front, 1 triangle, 11(13) squares and 1 triangle. TURN.

Continue straight for a further 5 rows. TURN.

With WSF work 1 triangle, 11(13) squares and 1 half triangle. TURN.

Leave the last 8 sts of previous row on a holder.

Work 11(13) squares. TURN.

Work 1 triangle, 10(12) squares. TURN.

Work 1 triangle and 10(12) squares. NB: leave a length of spare yarn on each square before breaking off to be used for grafting.

Leave all these sts on a holder.

Back (worked from cuff to cuff)

Pick up the sts provisionally cast on at underarm of right sleeve, and starting at cuff work 7(8) base triangles.

Leave aside for now.

Pick up the sts cast on for left sleeve and starting

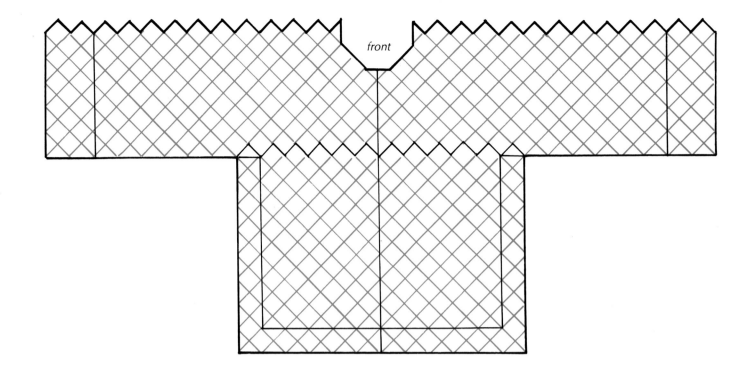

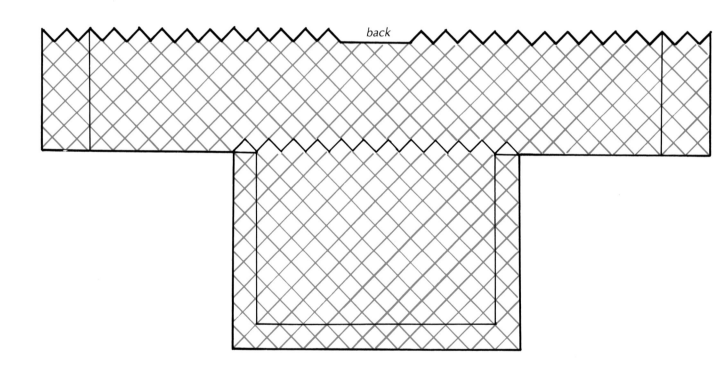

24

at underarm work 7(8) base triangles. TURN.
With WSF work across left sleeve, back and right
sleeve, 1 triangle, 27 squares and 1 triangle.
Continue straight for a further 7 rows. TURN.
With WSF work 1 triangle, 10(12) squares, 3 purl
cast-off triangles, 10(12) squares and 1 triangle.
NB: leave a length of spare yarn on each square
before breaking off to be used for grafting.
Graft fronts to back at shoulders.

Cuffs

With MC and a set of 3.25 mm needles PU and
knit 72(81) sts around sleeve ends. (K2 tog, p1)
to end of round. 48(54) sts.
Work 19 rounds in k1, p1 rib.
Cast off invisibly.

Front bands

Using 3.25 mm needles and MC, PU and knit
143(155) sts along centre front edges.
Work 10 rows in k1, p1 rib, making buttonholes
on 5th and 6th rows of right front if desired.
Cast off invisibly.

Neckband

Using 3.25 mm needles and MC, PU and knit
101 sts around neck including front bands.
Work 20 rows of k1, p1 rib.
Cast off loosely, fold neckband in half and slip
stitch to the inside.

In-the-round

At first I thought there was no way that I could shape entrelacs into a beanie, but determined not to be beaten I sat at it and came up with a style that can be made to fit any head and would not look out of place on any ski slope.

This is where backwards and forwards knitting comes into its own, as turning after every two or three stitches while working with five needles is enough to drive one to drink. It is also advisable to use two or more contrasting colours to be able to distinguish between one round and the next.

The headbands are also worked on double-ended needles and use the same technique as the hats. Work one round on the right side, then turn and work one round on the wrong side. There are still no seams to be joined, believe it or not.

Hats
(page 12)

Baby size: DK Baby Yarn and 5 double-ended needles, size 3.00 mm and 3.75 mm
Other sizes: 8-ply yarn and 5 double-ended needles, size 3.25 mm and 4 mm

Using a crochet hook, make 8 chain and join into a ring.

Using 3.75(4) mm needles and working into the chain, PU 2 sts and place on one needle, four times (8 sts on 4 needles).
2nd Round: Inc in each st (16 sts).
3rd Round: (K1, turn. P1, turn. K2, turn. P2, turn, k2) 8 times. Break off yarn. TURN.
4th Round: With WSF *PU p'wise 3 sts along edge of one triangle of previous row. Turn.
K3, turn, p2, p2 tog, turn, k3, turn, p2, p2 tog. Rpt from * to end of round. Break off yarn. TURN.

5th Round: With RSF *PU k'wise 4 sts along edge of one square of previous row. Turn.
(P4, turn, k3, SSK, turn) twice, p4, turn, k3, SSK. Rpt from * to end of round.

Continue increasing by picking up one extra stitch on each round until the hat is large enough.

For a baby or toddler work until there are 8 sts per square. For a child, 9 sts per square, for a woman, 10 sts per square and for a man 11 sts per square.

Work 1 round of either knit or purl cast-off triangles on the same number of sts as previous square.

Using 3(3.25) mm needles PU and knit 96(96,112,120,136) sts around brim and work 18(18,22,24,26) rows of k1, p1 rib.

Cast off invisibly (see page 14).

Headbands

(page 12)

Materials: 8-ply yarn
Needles: 5 × 4 mm double-ended

Cast on 24 sts, and work 4 base triangles over 6 sts (one triangle on each needle). Break off yarn. TURN.
*With WSF work 4 purl squares, break off yarn. TURN.

With RSF work 4 knit squares, break off yarn. TURN.
Rpt from * to length required.
For a woman work approximately 22 squares and for a man approximately 24.
Work 4 purl cast-off triangles in the same colour as the beginning triangles.
Join the end to the beginning without closing the tube.

Starting at the point

By commencing to work from the corner of a piece as opposed to the straight edge a whole new dimension opens up to the designer.

Shawls, bags and even basic shaped garments take on a whole new appearance as you can see from the small bag which I have worked in two shades of handspun yarn. This yarn was very coarse and I was saving it for a wall-hanging, but when I become engrossed in a project anything and everything goes into it!

Small bag

(page 12)

Work 2 pieces the same.

Materials: 8 ply yarn and 4 mm needles.

Cast on 10 sts and work 20 rows in st st. Break off yarn.

1st Row: Using 2nd colour, cast on 10 sts. (K9, SSK, turn. P10, turn) 9 times. K9, SSK. PU 10 sts along the side of the first square. Work 20 rows st st. TURN.

2nd Row: Using 1st colour, cast on 10 sts. (P9, p2 tog, turn, k10, turn) 9 times. P9, p2 tog. PU 10 sts p'wise. (K10, turn. P9, p2 tog, turn) 10 times. PU 10 sts p'wise. Work 20 rows st st.

Rpt Rows 1 and 2 until the bag is the size required from corner to corner.

On each row from now on, cast off the sts on the last row of the last square.

PU the 10 sts for next row from the inside edge of this last square and work one less square on each row until all sts are gone.

Work two rows of dc around each piece and then, with WS tog, join the pieces by working around 3 sides through both layers. Without breaking off yarn work across the top of the front piece and then across the top of the back, making a loop of crochet chain in the centre of this row if desired for a button loop.

Make a twisted cord for the strap and sew on a button.

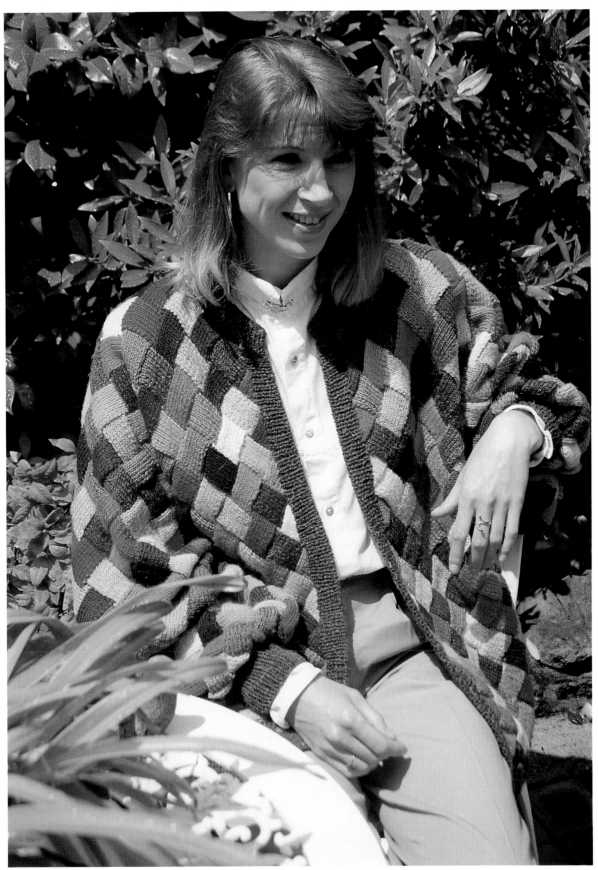

All-in-one woman's jacket (page 23)

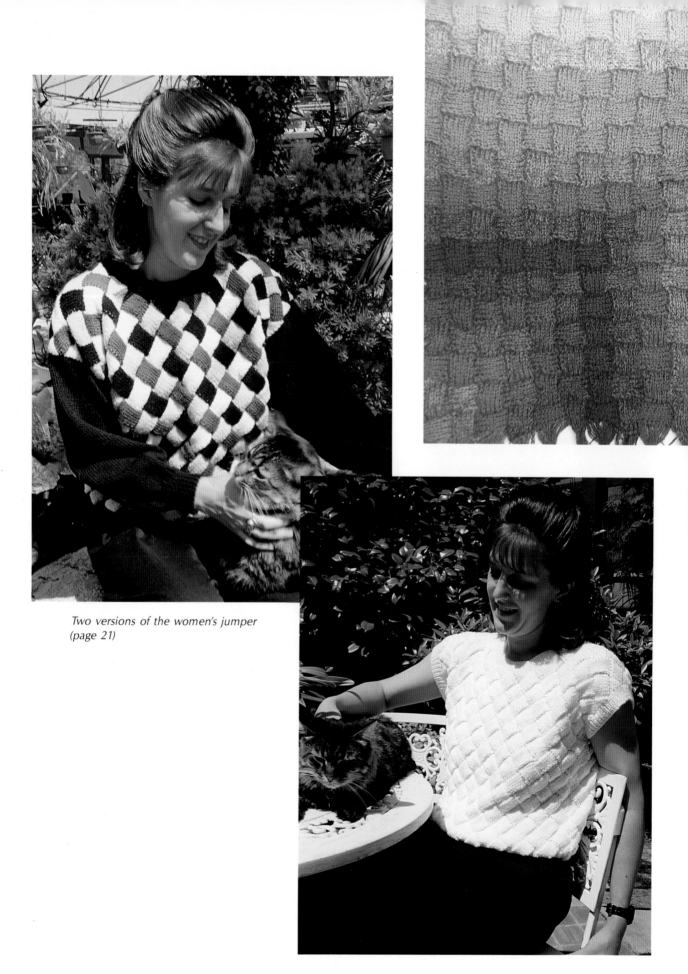

*Two versions of the women's jumper
(page 21)*

Multi-coloured shawl (page 33) with detail of shaded entrelacs opposite

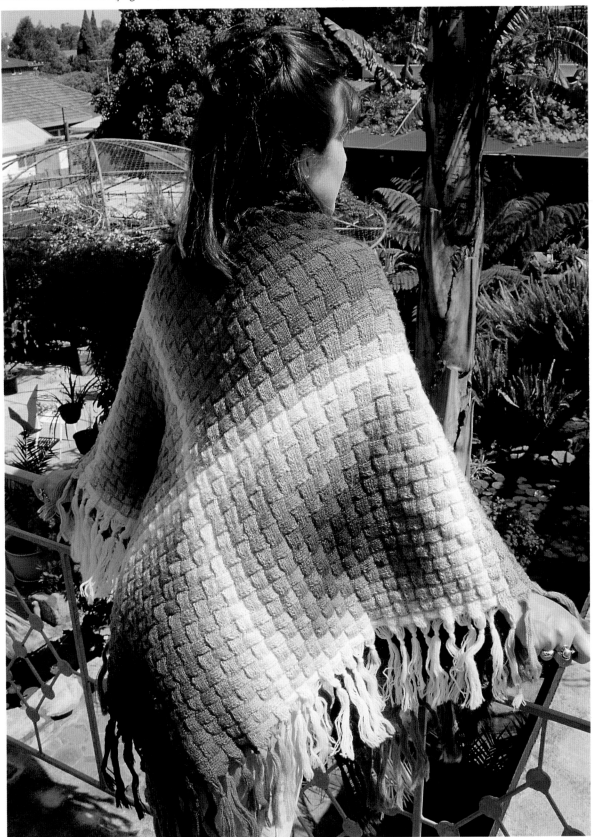

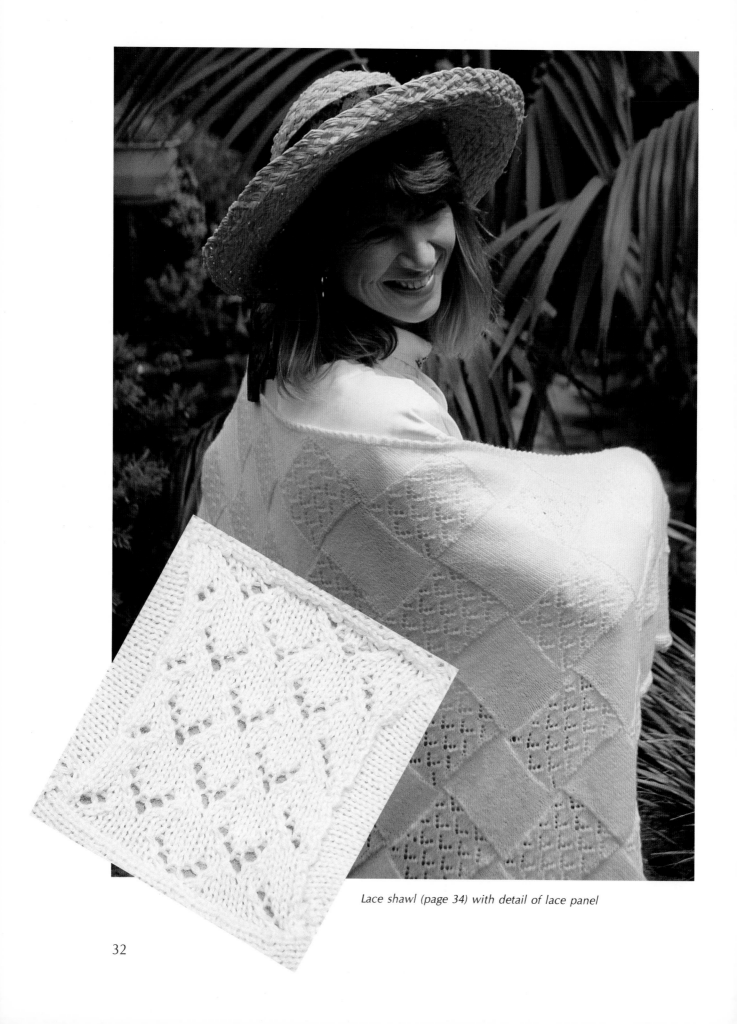

Lace shawl (page 34) with detail of lace panel

Shawls

Shawls are one of the things I most like to work as they have such a wonderful area on which to let the imagination run wild.

The first was inspired by a photograph of a patchwork quilt which I saw a few years ago in a magazine. Then I discovered Appleton's Embroidery Wools with all their rich and varied hues. Because they are so fine I was able to use two strands together and still only have about a four-ply yarn. Thus I was able to blend the colours by using one strand of each of two shades and then two strands of the same shade. In this way it is possible to almost double the number of shades obtained, i.e. 7 colours will produce 13 shades.

This exercise was extremely time-consuming and expensive although far from boring, and I hope you'll agree that the end result was well worth the effort.

For fine yarns with a wide choice of colours check out your weaving suppliers or suppliers of Shetland wools. The tension of the shawls is not important as far as size is concerned but it is best to work them at a soft tension so that they are not heavy and stiff. Plan your own design on graph paper before you start.

The lacy shawl was a by-product of the batwing sweater. Worked in two-ply pure wool it is light and feminine with sufficient warmth for a cool evening.

To work a square baby shawl, follow directions to required size and from then on, cast off on the last row of the last square each time until all sts are gone. Then work the border twice from opposite points.

Coloured shawl

(page 31)

Materials: 4 or 5-ply yarn
Needles: 3.25 or 3.75 mm long circular

Cast on 6 sts. Work 12 rows st. st. (Change colour here if desired.)
Cast on 6 sts.
*(K5, SSK, turn. P6, turn) 5 times. K5, SSK, * DO NOT TURN. PU 6 sts k'wise along side of first square, turn. P6.
Rpt from * to *. TURN.
Cast on 6 sts.
*(P5, p2 tog, turn. K6, turn) 5 times. P5, p2 tog, DO NOT TURN.
PU 6 sts p'wise. Rpt from * to last square, PU 6 sts.
Work 12 rows st. st. TURN.
Cast on 6 sts.
*(K5, SSK, turn. P6, turn) 5 times. K5, SSK. DO NOT TURN.
PU 6 sts k'wise. Rpt from * to last square, PU 6 sts.

Work 12 rows st. st. TURN.

Repeat the last two rows of squares until the shawl is the size you want it to be, ending with a wrong side row.

Because the stitches are gathered up on the needle it is very hard to judge the width—don't forget Pythagoras!

Last row of triangles:
With RSF cast on 6 sts.
*K5, SSK, turn. P4, p2 tog, turn.
K4, SSK, turn. P3, p2 tog, turn.
K3, SSK, turn. P2, p2 tog, turn.
K2, SSK, turn. P1, p2 tog, turn.
K1, SSK, turn. P2 tog, turn.
SSK. DO NOT TURN.

Fasten off but do not break yarn unless changing colour.
PU 6 sts, turn. P6, turn.
Rpt from * to last square.
PU 6 sts, turn. P4, p2 tog, turn.
K5, turn. P3, p2 tog, turn.
K4, turn. P2, p2 tog, turn.
K3, turn. P1, p2 tog, turn.
K2, turn. P2 tog. Fasten off.

Border
With WSF PU p'wise 8 sts across each triangle just worked.
Work 8 rows of st st.

Next row: K2 (yfwd, k2 tog) to end of row.
Work 9 rows in st st. Cast off loosely.
Fold border in half and slip stitch into place on wrong side.
Attach fringe to other two sides.

Lace shawl

(page 32)

May be worked in any yarn on appropriate size needles.
Use provisional cast on throughout (see page 14).

Cast on 24 sts. Purl 1 row.
Work graph 4 times, ending with a purl row. TURN.
With RSF cast on 24 sts. K24, turn.
(P24, turn. K23, SSK, turn) 24 times. DO NOT TURN.
PU k'wise 24 sts along the side of the first square.
Work 48 rows in st st. TURN.
With WSF cast on 24 sts, p24, turn.

Work graph 4 times, working p23, p2 tog on alt rows. DO NOT TURN.
*PU p'wise 24 sts along the side of the next square and work lace panel. DO NOT TURN.
Rpt from * to end of row. TURN.

With RSF cast on 24 sts. K24, turn.
(P24, turn. K23, SSK, turn) 24 times. DO NOT TURN.
*PU k'wise 24 sts along the side of the next square, turn.
(P24, turn. K23, SSK, turn) 24 times.
Rpt from * to last square. PU k'wise 24 sts and work 48 rows in st st. TURN.

Continue to work from diagram until size required, casting on 24 sts at the beginning of each row of squares and placing lace panels where desired, finishing with a row of wrong side squares. TURN.

Last row: Cast on 24 sts.
K24, turn. P24, turn.
K23, SSK, turn. P22, p2 tog, turn.
K22, SSK, turn. P21, p2 tog, turn.
K21, SSK, turn. P20, p2 tog, turn.

Continue to decrease in this way until one stitch remains.
Fasten off but do not break yarn.
Work a row of knit cast-off triangles (see page 7).
Last triangle: PU 24 sts, turn. P22, p2 tog, turn.
K23, turn. P21, p2 tog, turn.
K22, turn. P20, p2 tog, turn.
Continue to decrease at the end of each purl row until 1 st remains.
Fasten off.

Border
PU 24 sts of each square along RH edge.
Leave aside.
Cast on 3 sts.
K3, turn. K1, p1, k1, turn.
K1 (M1, k1) twice, turn. K1, p to last st, k1, turn.
K2, YO, k1, YO, k2, turn. K1, p to last st, k1, turn.
K2, YO, k3, YO, k2, turn. K1, p3, inc in centre st, p3, k1, turn.

Working on the first 5 of these sts only and the sts picked up along edge of shawl:
Row 1: K2, YO, k2, SSK (by working together one st from border and the first stitch from the point of the shawl). Leave rem 5 sts on a thread.
Row 2 and alt rows: Purl to last st, k1.
Row 3: K2, YO, k3, SSK.
Row 5: K2, YO, k4, SSK.
Row 7: K2, YO, k1, k2 tog, YO, k2, SSK.
Row 9: K1, SKP, YO, SKP, k3, SSK.
Row 11: K1, SKP, YO, SKP, k2, SSK.
Row 13: K1, SKP, YO, SKP, k1, SSK.
Row 15: K1, SKP, YO, SKP, SSK.
Row 16: As 2nd row.
Rpt the last 16 rows until all sts of main piece are worked off.
Leave sts on a thread.
PU sts along the other side of shawl and working across the 5 sts of border:
Row 1: K3, YO, k2.

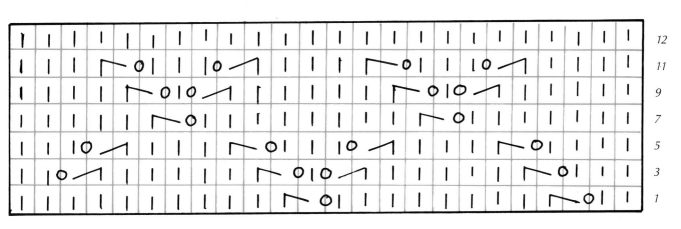

| | | | | Knit on RS, purl on WS | | | | K2 tog | | | | Every even-numbered row is purl |

SKP O YO

Row 2 and alt rows: K1, p to last st, p2 tog.
Row 3: K4, YO, k2.
Row 5: K5, YO, k2.
Row 7: K3, YO, SKP, k1, YO, k2.
Row 9: K4, k2 tog, YO, k2 tog, k1.
Row 11: K3, k2 tog, YO, k2 tog, k1.
Row 13: K2, k2 tog, YO, k2 tog, k1.
Row 15: K1, k2 tog, YO, k2 tog, k1.
Row 16: As 2nd row.
Rpt the last 16 rows until all sts of main piece are worked off.

Hem
With WSF work across border, pick up p'wise 30 sts across the top of each triangle and work across the other border.
Work 2 to 4 cm in stocking stitch (depending on the thickness of the yarn used).
Next row: K2 (k2 tog, yfwd) to last 2 sts, k2.
Work the same number of rows again in stocking stitch, ending with a wrong side row.
Cast off loosely.
Fold hem in half and slip stitch loosely to the wrong side.
Block shawl to shape.

Garterstitch waistcoats

(page 9)

These waistcoats are both worked in 4-ply equivalent yarns. The beautiful soft colours of the woman's waistcoat are Shetland 2-ply pure wool, and the man's is Shepherd crepe.

I decided to work the fronts in garter stitch to make them a different texture from the back. However, this caused a slight hiccup at first until I realised that garter stitch can just as easily be every row purl as every row knit...

Use the chart provided to design your garment before you begin and then remember to change the colours as planned.

Finished measurement: 95(100,115) cm at underarm
Materials: 4-ply or equivalent yarns (at least 125–150 g in MC for back and bands)
Needles: 3.25 mm
Tension: 14 sts to 5 cm over st st

Special instructions

Each square started with RSF is all knit.
Each square started with WSF is all purl.

Triangle at beginning of row in garter stitch:
K(p)1, turn. Inc in this st, turn.
K(p)1, SSK(p2 tog),, turn. Inc in first st, k(p)1, turn.
K(p)2, SSK(p2 tog), turn. K(p)1, inc in next st, k(p)1, turn.
K(p)3, SSK(p2 tog), turn. K(p)2, inc in next st, k(p)1, turn.
K(p)4, SSK(p2 tog), turn. K(p)3, inc in next st, k(p)1, turn.
K(p)5, SSK(p2 tog).

Triangle at end of row in garter stitch:
PU 6 sts k'wise(p'wise), turn. K(p)6, turn.
K(p)4, k(p)2 tog, turn. K(p)5, turn.
K(p)3, K(p)2 tog, turn. K(p)4, turn.
K(p)2, k(p)2 tog, turn. K(p)3, turn.
K(p)1, k(p)2 tog, turn. K(p)2 tog. Fasten off.

Cast-off triangle in garter stitch:
PU 6 sts k'wise(p'wise) turn. K(p)6, turn.
K(p)5, SSK(p2 tog), turn. K(p)4, k(p)2 tog, turn.
K(p)4, SSK(p2 tog), turn. K(p)3, k(p)2 tog, turn.
K(p)3, SSK(p2 tog), turn. K(p)2, k(p)2 tog, turn.
K(p)2, SSK(p2 tog), turn. K(p)1, k(p)2 tog, turn.
K(p)1, SSK(p2 tog), turn. K(p)2 tog, turn.
SSK(p2 tog). Fasten off.

Left front

Cast on 6 sts and work 12 rows in purl. Break off yarn if changing colour.
Using a new colour cast on 6 sts.
(K5, SSK, turn. K6, turn) 5 times. K5, SSK, DO NOT TURN.
PU 6 sts k'wise. Work 12 rows knit on these 6 sts only. Break off yarn. TURN.
Changing colours as desired, continue to work your design from your chart.
Cast on 6 sts.
*(P5, p2 tog, turn. P6, turn) 5 times. P5, p2 tog. DO NOT TURN.
PU 6 sts p'wise, turn. P6, turn.* Rpt from * to * until you are on the last square, then work 11 more rows purl. TURN.
Cast on 6 sts.
*(K5, SSK, turn. K6, turn) 5 times. K5, SSK, DO NOT TURN.
PU 6 sts k'wise, turn. K6, turn.* Rpt from * to * until you are on the last square, then work 11 more rows in knit. TURN.
Work the last two rows alternately until there are 7(8,9) squares on the needle.

1st and 3rd sizes only:
With RSF work 1 triangle, 6(8) squares and 1 triangle. TURN.
With WSF work 7(9) squares. TURN.
Rpt last two rows 3 times more and 1st row once.

Next row: Work 6(8) squares and 1 cast-off triangle. Fasten off. TURN.
Place the first 6 sts on a holder.
Work 5(7) squares and 1 triangle. TURN.
Work 5(7) squares. TURN.
Place the first 6 sts on a holder.

1st size only:
Work 4 squares and 1 triangle. TURN.
Work 4 squares and 1 triangle. TURN.
Work 4 squares. TURN.
Place the first 6 sts on a holder.
Work 3 squares and 1 triangle. TURN.
Work 3 squares. TURN.

Place the first 6 sts on a holder.
Work 2 squares and 1 triangle. TURN.
Work 2 squares. TURN.
Work 1 triangle, 1 square and 1 triangle. TURN.
Rpt the last 2 rows to length required.
Finish off with 2 cast-off triangles.

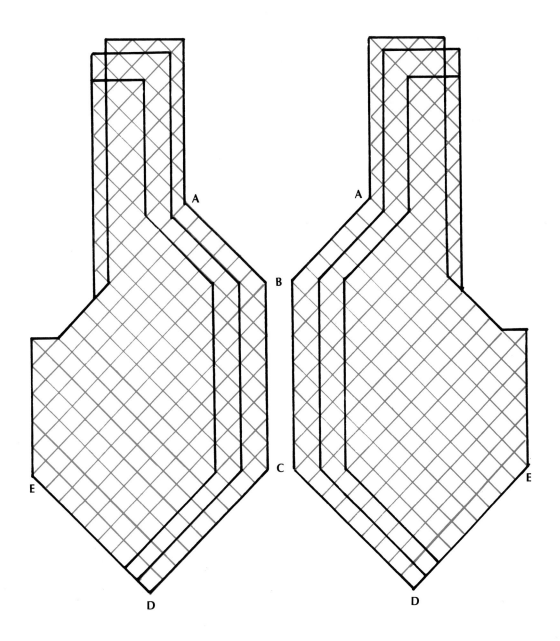

3rd size only:
Work 6 squares and 1 triangle. TURN.
Work 6 squares. TURN.
Work 1 triangle and 5 squares. TURN.
Place the first 6 sts on a holder.
Work 5 squares. TURN.
Work 1 triangle and 4 squares. TURN.
Place the first 6 sts on a holder.
Work 4 squares. TURN.
Work 1 triangle and 3 squares. TURN.
Place the first 6 sts on a holder. TURN.
Work 3 squares. TURN.
Work 1 triangle, 2 squares and 1 triangle.
TURN.
Rpt last two rows to length required.
Finish with 3 cast-off triangles.

2nd size only:
With WSF work 1 triangle, 7 squares and 1
triangle. TURN.
Work 8 squares. TURN.
Rpt the last 2 rows 3 times more and the 1st
row once.
With RSF work a cast-off triangle and 7 squares.
TURN.
Work 1 triangle and 6 squares. TURN.
Place the first 6 sts on a holder.
Work 6 squares. TURN.
Work 1 triangle and 5 squares. TURN.
Place the first 6 sts on a holder.
Work 5 squares. TURN.
Work 1 triangle and 4 squares. TURN.
Place the first 6 sts on a holder.

Work 4 squares. TURN.
Work 1 triangle and 3 squares. TURN.
Place the first 6 sts on a holder.
Work 3 squares. TURN.
Work 1 triangle, 2 squares and 1 triangle. TURN.
Rpt the last 2 rows to length required.
Finish with 3 cast-off triangles.

Right front

Work the same as left front until the armhole shaping is reached, and then reverse all shaping according to the chart.

Back

Cast on 119(135,151) sts.
Work 10 rows in k1, p1 rib.
Work in st st until the back measures the same above the rib as the front to armholes.
Cast off 8(8,10) sts at the beginning of the next two rows.
Dec 1 st at each end of the following and alternate rows 10(10,14) times.
Continue straight until back armhole measures the same as the front.

Cast off 16(24,24) sts at the beginning of the next two rows.
Work 10 rows in k1, p1 rib.
Cast off invisibly.

Bands

With RSF begin at left front shoulder and PU 6 sts k'wise for every square or triangle all around left front edge.
Work 9 rows in k1, p1 rib, inc 1 st on each alt row at B and C, 2 sts on each alt row at D, and dec 1 st on each alt row at A and E.
Cast off invisibly.
With WSF begin at right front shoulder and PU 6 sts p'wise for every square or triangle all around right front edge.
Work to match left band.
Join fronts to back at shoulders.
With RSF, PU sts from left front armhole as before, and the same number of stitches from back armhole.
Work 9 rows in k1, p1 rib. Cast off invisibly.
Work right armhole in reverse.
Sew up side seams.

Batwing sweaters

(inside back cover)

I still find it hard in these enlightened times to find a good pattern that has actually been designed for larger women.

This is why I always design my own jumpers and jackets, so that they are loose, comfortable and light. These sweaters, however, because of their shape look good on anyone. They are the same style but in different designs. The sweater in 8-ply for daywear has classic Argyle panels and is warmer.

The lacy design is in 5 or 6-ply and is quite suitable for a winter's evening.

Both sweaters have been worked at a slightly looser tension than normally recommended, and I used Anny Blatt pure wool, as the soft woollen spin of the yarn helps the sleeves to fall and drape, an effect not obtainable with a crepe yarn.

The chart for the lace panel in the 5-ply sweater is that used for the shawl on page 34.

Measurement: Two sizes only, to fit up to a 22
Materials: 1000 g of Anny Blatt No. 5 (8-ply) or 900 g of No. 4 (5/6-ply). These quantities will vary if some contrast colours are used.
Tension:
　20 sts to 10 cm on 4.5 mm needles and 8-ply yarn
　24 sts to 10 cm on 4 mm needles and 5 or 6-ply yarn

Instructions are for 8-ply (5/6-ply instructions are in brackets)

Front

Using 3.25 (3.00) mm needles, cast on for size 12–16, 98(122) sts, or for size 18–22, 118(142) sts.
Work in rib as follows:
1st Row: (P2, k2), rpt to last 2 sts, p2.
2nd Row: (K2, p2), rpt to last 2 sts, k2.

Argyle panel in 3 colours
for 8-ply batwing sweater

O				X				O		O				Z				O
	O		X	X	X		O				O		Z	Z	Z		O	
		O	X	X	X	O					O	Z	Z	Z	O			
	X	X	O	X	O	X	X			Z	Z	O	Z	O	Z	Z		
X	X	X	X	O	X	X	X	X	Z	Z	Z	Z	O	Z	Z	Z	Z	
	X	X	O	X	O	X	X		Z	Z	O	Z	O	Z	Z			
		O	X	X	X	O				O	Z	Z	Z	O				
	O		X	X	X		O				O	Z	Z	Z		O		
O				X				O		O				Z				O
									O									
O				Z				O		O				X				O
	O		Z	Z	Z		O				O		X	X	X		O	
		O	Z	Z	Z	O					O	X	X	X	O			
	Z	Z	O	Z	O	Z	Z			X	X	O	X	O	X	X		
Z	Z	Z	Z	O	Z	Z	Z	Z	X	X	X	X	O	X	X	X	X	
	Z	Z	O	Z	O	Z	Z		X	X	O	X	O	X	X			
		O	Z	Z	Z	O				O	X	X	X	O				
	O		Z	Z	Z		O				O	X	X	X		O		
O				Z				O		O				X				O
									O									
O				X				O		O				Z				O
	O		X	X	X		O				O		Z	Z	Z		O	
		O	X	X	X	O					O	Z	Z	Z	O			
	X	X	O	X	O	X	X			Z	Z	O	Z	O	Z	Z		
X	X	X	X	O	X	X	X	X	Z	Z	Z	Z	O	Z	Z	Z	Z	
	X	X	O	X	O	X	X		Z	Z	O	Z	O	Z	Z			
		O	X	X	X	O				O	Z	Z	Z	O				
	O		X	X	X		O				O	Z	Z	Z		O		
O				X				O		O				Z				O
									O									
O				Z				O		O				X				O
	O		Z	Z	Z		O				O		X	X	X		O	
		O	Z	Z	Z	O					O	X	X	X	O			
	Z	Z	O	Z	O	Z	Z			X	X	O	X	O	X	X		
Z	Z	Z	Z	O	Z	Z	Z	Z	X	X	X	X	O	X	X	X	X	
	Z	Z	O	Z	O	Z	Z		X	X	O	X	O	X	X			
		O	Z	Z	Z	O				O	X	X	X	O				
	O		Z	Z	Z		O				O	X	X	X		O		
O				Z				O		O				X				O

3rd Row: *P2, knit into second st on LH needle and then into the first and take them off together (tw2). Rpt from * to last two sts, p2.
4th Row: As 2nd row.

Repeat these four rows 4 times more and then the first row once again.
Change to larger needles, and with WSF dec evenly across row to 80(96) sts for both sizes.

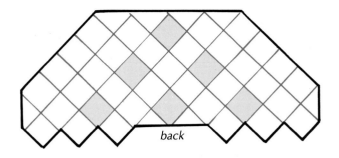

back

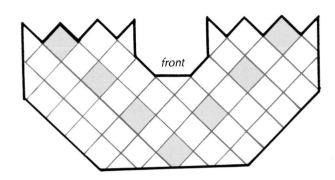

front

Work 4 base triangles over 20(24) sts (see instructions on page 6).

1st Row of Squares: Cast on 20(24) sts. *(P19(23), p2 tog, turn. K20(24), turn) 19(23) times, turn. P19(23), p2 tog. DO NOT TURN.
PU 20(24) sts p'wise. Rpt from * to last square, working pattern in 3rd square if desired.
Work 40(48) rows in st st. TURN.

2nd Row of Squares: Cast on 20(24) sts. *(K19(23), SSK, turn. P20(24), turn) 19(23) times, turn. K19(23), SSK. DO NOT TURN.
PU 20(24) sts k'wise. Rpt from * to last square.
Work 40(48) rows in st st.

Continue to work from chart, referring to page 8 for triangles at sleeve ends and neck.
Leave sts not needed at neck on holder.
Leave sts at shoulders on spare needle ready for grafting.

Back

Begin as for front, but follow chart for neck shaping.
Graft front to back at shoulders, following instructions on page 15 for joining stitches to rows.

Cuffs

Using smaller needles PU and knit 50(58) sts across sleeve ends and work 26 rows in rib as for back.
Cast off loosely.

Neck

Using smaller needles PU and knit 210(246) sts evenly around neck.
Rounds 1 and 2: (P4, k2) to end.
Round 3: (P4, tw2) to end.
Round 4: As round 1.
These 4 rows form the pattern; work 8 more rounds.
Dec round: (P1, p2 tog, p1, k2) to end.
Keeping pattern as now set, work 7(11) more rounds.
Dec round: (P1, p2 tog, k2) to end.
Keeping pattern as now set, work 11(11) more rounds.
Cast off loosely in rib.
Turn the last 8 rounds to the inside and slip stitch into place.
Join side seams.